TOM OTTERNESS

THE PUBLIC UNCONSCIOUS

October 4 - November 3, 2007

Marlborough Chelsea

545 West 25th Street, New York, NY 10001
Telephone 212.463.8634, Fax 212.463.9658
chelsea@marlboroughgallery.com

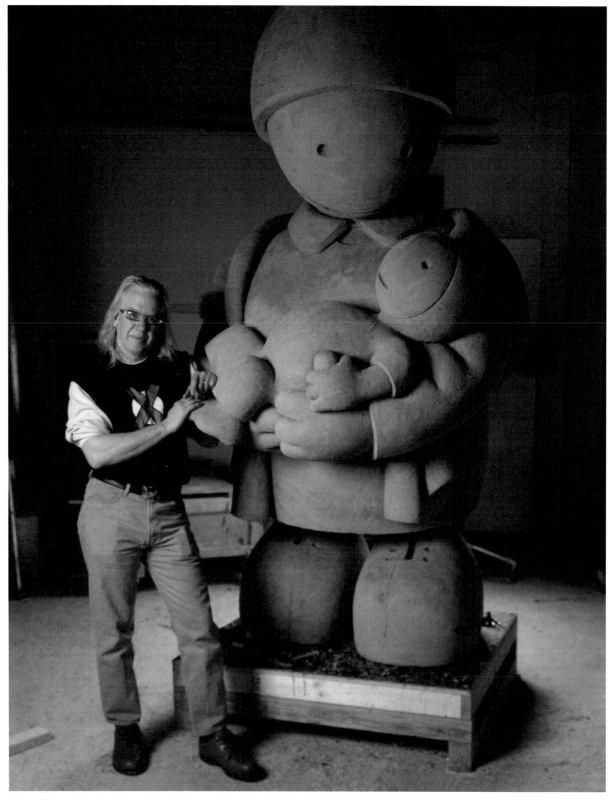

Tom Otterness standing with Immigrant Family (work in progress), 2007
Clay model of female figure, 98 x 55 x 59 in., 248.9 x 139.7 x 149.9 cm

THE PUBLIC UNCONSCIOUS

In his public sculptures inhabiting parks, plazas, and courthouses across the country, Tom Otterness has long tackled themes of money, religion, sex, and class that ripple through our national psyche. Often alluding to fairy tales and political cartoons, Otterness's figures and animals cast in bronze have a lovability and extreme cuteness that belie their subversive edge and allow the artist to carry controversial subjects into the public domain like a Trojan horse.

Some twenty new sculptures, many generated from collaborations with communities around the nation and beyond, are brought together in *The Public Unconscious*, the artist's first major gallery show in five years. Walking into this menagerie full of characters and creatures with tremendous disparities in scale and slippery meanings is a bit like being pulled through the looking glass. A ten-foot-long millipede wears a top hat and chunky shoes on its multitude of little feet that support its sleek, torpedo-like body. Is it a commentary on how society works together in healthy cooperation or walks blindly in lockstep? Such multiple readings reverberate throughout these works that for Otterness reflect a kind of collective dream life and self-portrait of the country.

The emotional center of the show for the artist – who was born in 1952 in Wichita, Kansas, and has worked in the public sphere since becoming a member of Collaborative Projects in New York in 1977 – is *Immigrant Family*, a monumental grouping of figures stretching almost ten feet in each direction. Otterness's signature treatment of his figures is influenced by animation from the 1920s and 1930s and the geometric figures of early Malevich as well as WPA artists who looked to many cultures and boiled down a universal language. Part of what's unexpected in Otterness's simple cartoon world is that the details feel so true. In *Immigrant Family*, a mother and a father are dressed in immigrants' garb and cradle their baby who looks out to the world. The contact places between forms – where the button on the man's vest pulls on the fabric or where the baby clutches its mother's thumb – are critical for the artist who wants the viewer to recognize something physically convincing even within the radical distortions. Expressively, too, he's looking for what is essential. Otterness, who finds that almost all Americans have an immigrant story in their family history, invests the promise of the New World in the new life of the baby. He even made tortuous full-scale changes, including lopping off the giant head of the father who was originally looking outward and repositioning his gaze on the infant, to reinforce the idea of parents looking to their future in their children.

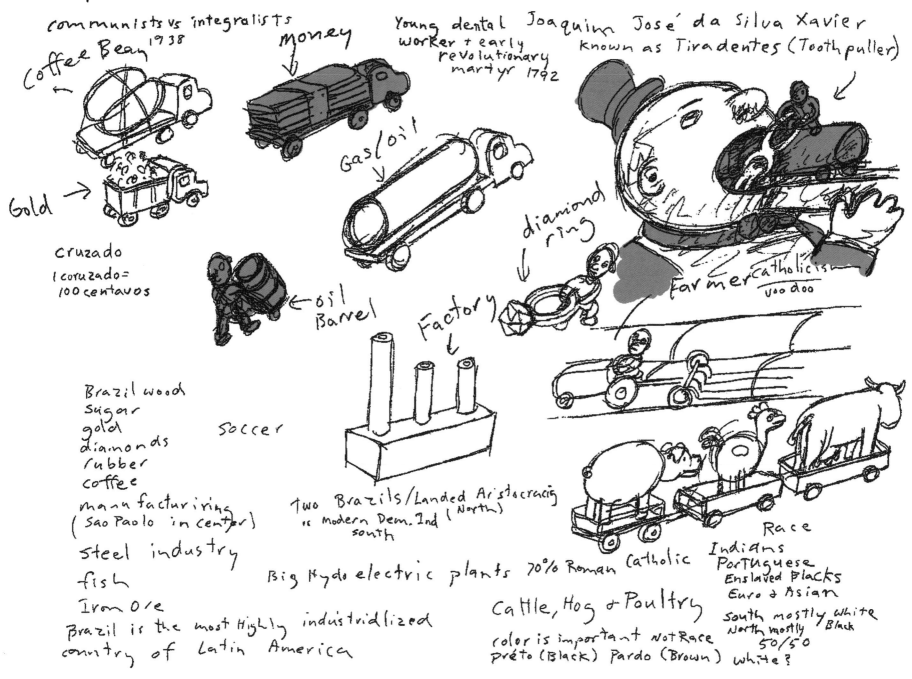

SAO PAOLO PROPOSAL ②

communists vs integralists
Coffee Bean 1938

money

Young dental worker + early revolutionary martyr 1792

Joaquim José da Silva Xavier known as Tiradentes (Tooth puller)

Gas/oil

Gold →

cruzado
1 coruzado = 100 centavos

diamond ring

oil Barrel

Factory

farmer Catholicism
Voo doo

Brazil wood
sugar
gold
diamonds
rubber
coffee
manufacturing
(Sao Paolo in center)

Soccer

Two Brazils/Landed Aristocracig (North)
is modern Dem. Ind
south

steel industry
fish
Iron Ore
Brazil is the most Highly industrialized
country of Latin America

Big Hydo electric plants 70% Roman Catholic

Cattle, Hog & Poultry
color is important Not Race
Préto (Black) Pardo (Brown)

Race
Indians
Portuguese
Enslaved Blacks
Euro & Asian
South mostly white
North mostly Black
50/50
white?

Notebook drawing for São Paulo Biennial proposal, 2005
pencil on paper

4

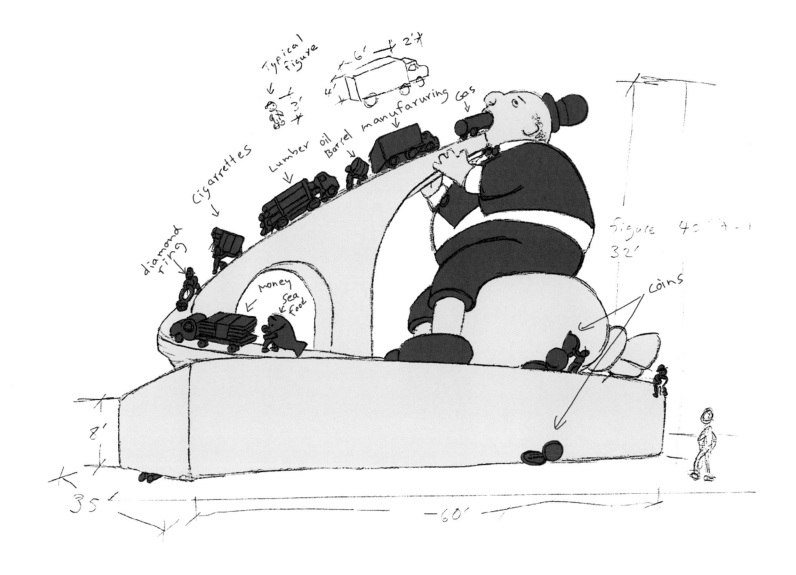

Probably the most pointed social satire in the show is Otterness's *The Consumer*, reprising his familiar theme of fat cats and their obsession with money. Inspired by a political cartoon of an obese man literally swallowing up trucks and industry, Otterness has sent a convoy of commodities – including an oil tanker, a lumber truck, a pack of cigarettes, and a diamond ring – up a ramp and into the open mouth of an almost spherical figure sitting on a money bag spilling out coins. Originally conceived as a 40-foot balloon for a project in São Paulo that didn't come to fruition, the almost eight-foot-high bronze figure stands as a universal symbol of unthinking avarice and retains the sense of an inflatable that's about to burst.

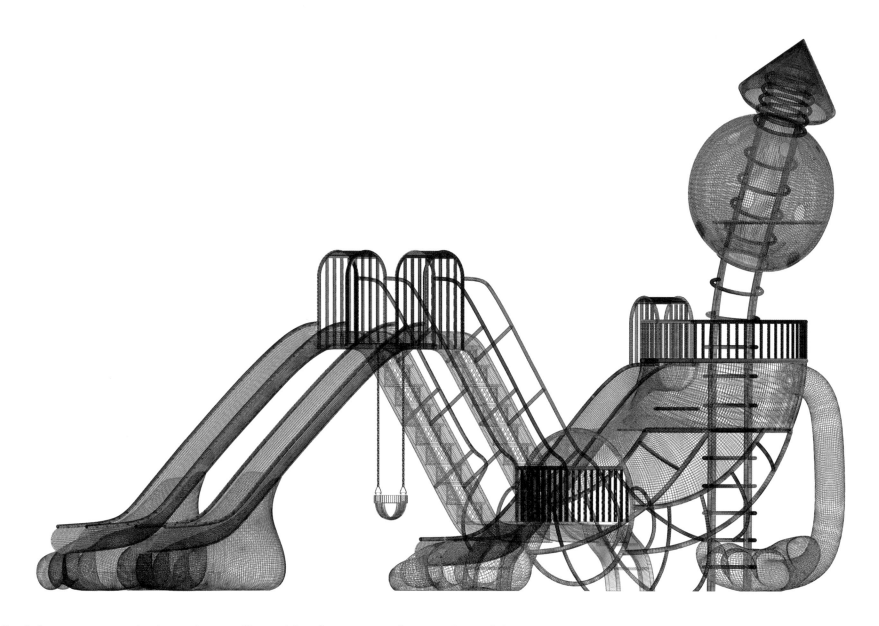

All of these new works have been affected by Otterness's integration of the computer into his design process over the last five years. This first began with a giant figural play structure he built almost entirely on screen that he considers a step toward his ambitions to make anthropomorphic architecture. The ability to mentally move around inside the structure through computer animation during the conception stages opened up a new window for him. Now, digitally generating pieces at radically different scales with ease, before working on his models by hand in clay, has become the standard way for him to think about sculpture. He extracted a small mouse, for instance, from a vignette based on Aesop's Fables that he did in The Netherlands in 2004 and for this show bumped it up

Wireframe model for Playground

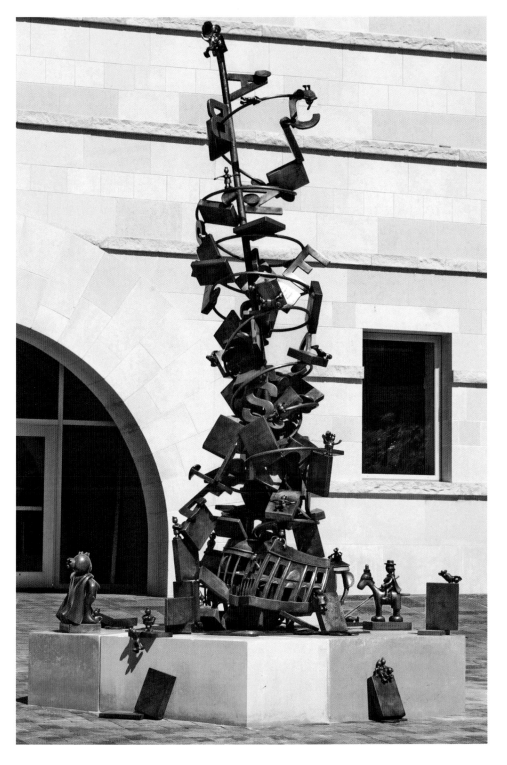

to nine feet. The towering mouse, with its hands behind its back staring down quizzically at the viewer, creates an odd psychological dynamic. So does the huge crazy-eyed frog, from a 2004 public project at the Camuy Caverns in Puerto Rico, which has the viewer in its sights and looks ready to spring. Are they cute or menacing, benign or malevolent? In Otterness's wonderland, the ground is always shifting.

Most of these individual works come out of Otterness's public projects that reflect the character of communities he works with; but when cut free of a larger context, the works take on meanings of their own – just as Auguste Rodin's *The Thinker* exists independently of *The Gates of Hell* where the motif originated. In a project Otterness completed in 2004 for Texas Tech University in Lubbock, for instance, a king and queen titled *Free Thinkers* watch as a big tornado of right-wing and left-wing books tear apart a model of the White House. Reworked now as a stand-alone sculpture, the disgruntled king and more curious queen, naked save their crowns and robes pulled back, seem to be defiant radicals throwing off their Emperor's new clothes and thinking for themselves.

Tornado of Ideas, 2004
Texas Tech University, Lubbock, Texas

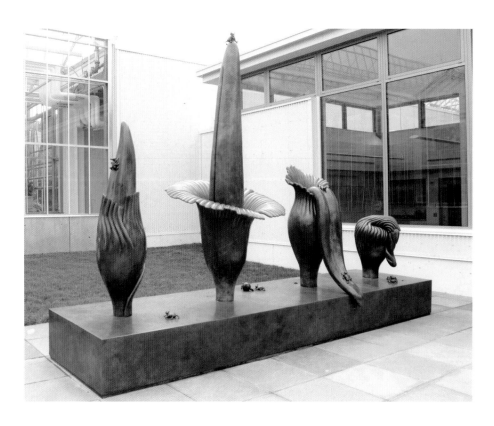

This majestic bronze sculpture by Tom Otterness graces the entrance plaza of the Nolen Greenhouses for Living Collections at The New York Botanical Garden. The sculpture depicts various stages in the life cycle of "Amorphophallus titanum," known as the largest "flower" in the world. The plant, native to Sumatra, was brought into bloom for the first time in the Western hemisphere at the Botanical Garden in 1937. The flower created a national sensation as it grew to over eight feet tall – visitors thronged to the Botanical Garden, having heard about the phenomenon "via newspaper, radio, and news-reel."

The "Amorphophallus titanum's" powerful smell attracts the Sumatra Dung Beetle, whose explorations of the plant's stamens serve to carry its pollen to a receptive female pistil. In his work, Otterness has substituted small coins to symbolize the pollen. Drawn by the plants' pungent odor, Wealthy Dung Beetles cross-pollinate the plants by unknowingly transporting the pollen (money) from plant to plant in a futile search for dung to build nests and to feed their young.

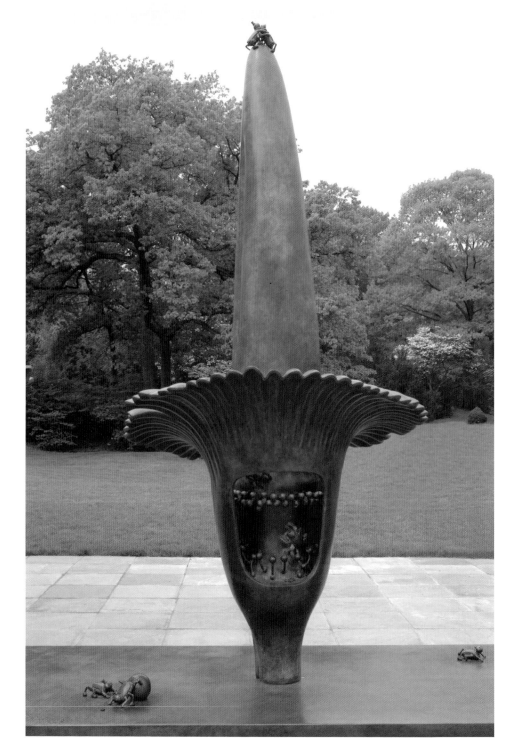

Amorphophallus titanum, 2005
Permanent installation at The Nolen Greenhouses for Living Collections,
The New York Botanical Garden, Bronx, New York, 126 x 192 x 48 in., 320 x 487 x 122 cm

Other small works in the show, including a lilliputian figure scaling a microscope to examine a second little figure splayed out under the lens, come from a project in process for the city of Claremont, California, where the concept of "Intelligent Design" originated. There, in a public fountain, Otterness conceived a debate between evolving fish – who play with blocks, learn to read and write, and turn into lizards with graduation caps – and a snake wearing a doctorate's tam with a bible and an apple.

Kissing Dung Beetles is another recent sculpture born of a larger project, a commission the artist completed in 2005 for the Nolen Greenhouses at The New York Botanical Garden in the Bronx, New York. He pulled out the small-scale motif of amorous insects from his bronzes of a giant phallic plant called *Amorphophallus titanum* in the Botanical Garden, and enlarged the dung beetles – kissing in a grappling embrace atop a money bag – to seven feet. In its new incarnation, whether the dung beetles are in love with each other or the money is up for grabs, but their passion is real. Otterness remembers the profound effect as a child of reading Franz Kafka's famous story *The Metamorphosis*, in which Gregor Samsa awoke to find he had been changed into a monstrous bug. "It's hard to describe how convincing it seemed to me," says Otterness. "I look at *Kissing Dung Beetles* and think it could be Gregor if he didn't die in his room alone but got therapy, found a mate, and made some money." Using such humor and optimism to float murkier personal and collective issues is the defining quality of Otterness's allegories.

- Hilarie Sheets

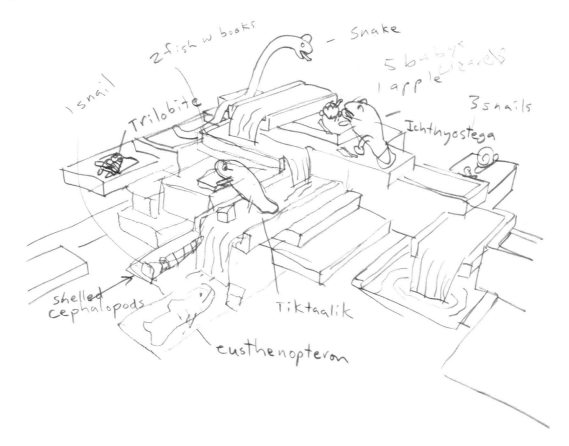

Notebook drawing for Claremont, California proposal, 2005
pencil on paper

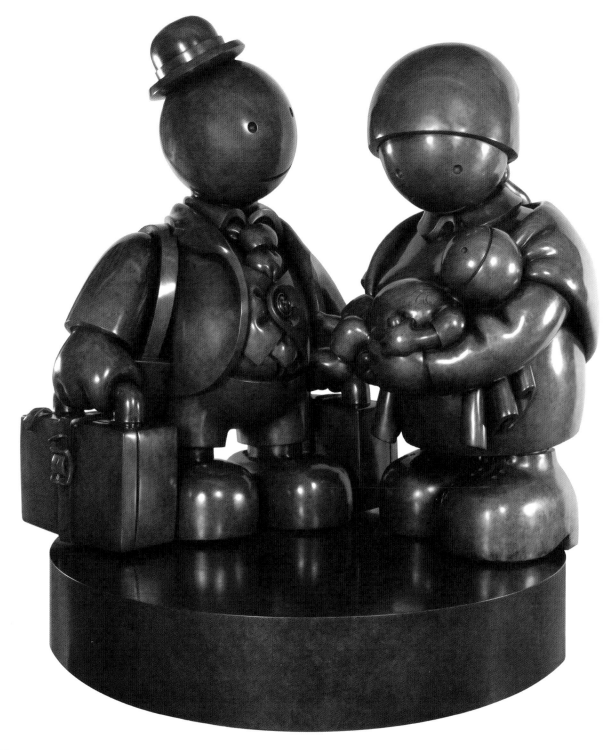

1. **Immigrant Family**, 2007
 bronze, edition of 3, 129 x 121 x 108 in., 327.7 x 307.3 x 274.3 cm

Another version of this sculpture exists in an edition of 9, 32¾ x 32½ x 32½ in., 83.2 x 82.6 x 82.6 cm

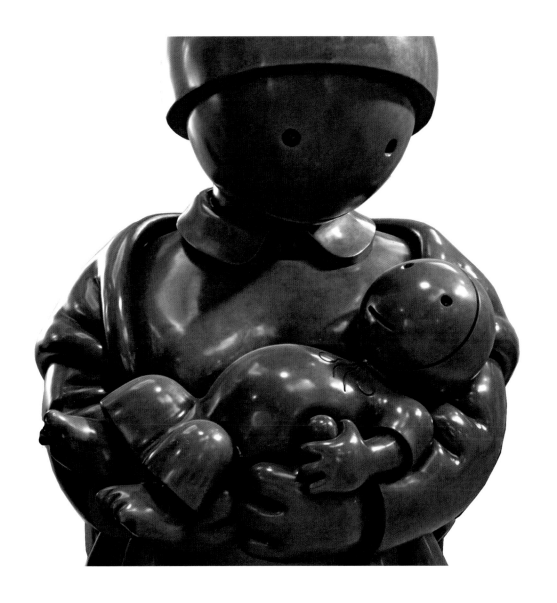

Immigrant Family (detail)

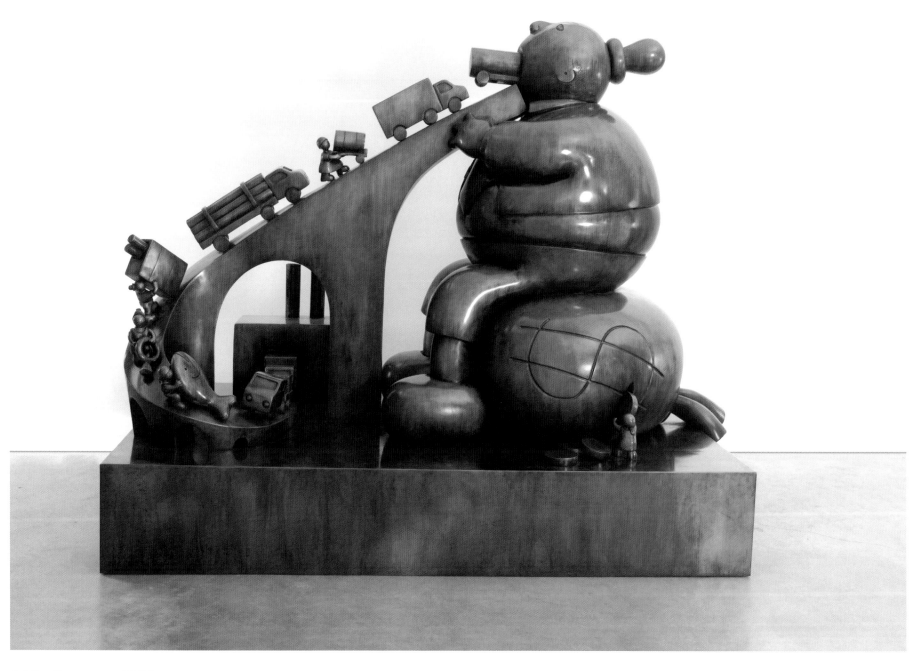

2. **The Consumer**, 2007
 bronze, edition of 3, 81 x 60 x 92 in., 205.7 x 152.4 x 233.7 cm

 Another version of this sculpture exists in an edition of 9, 27 x 30 x 20 in., 68.6 x 76.2 x 50.8 cm

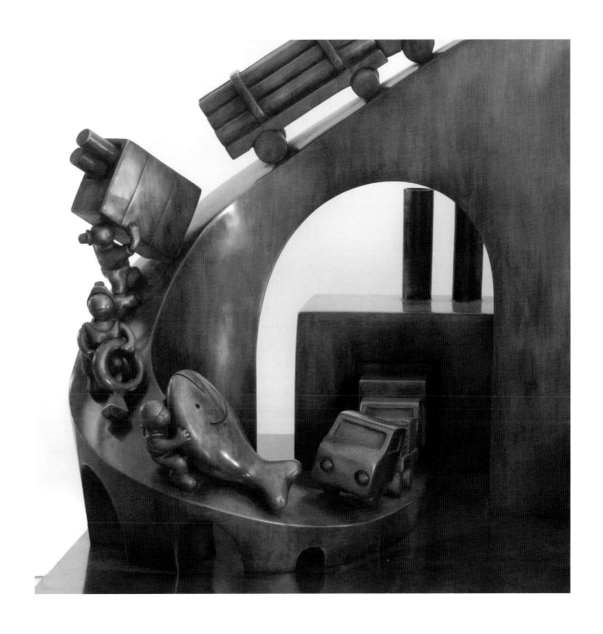

The Consumer (detail)

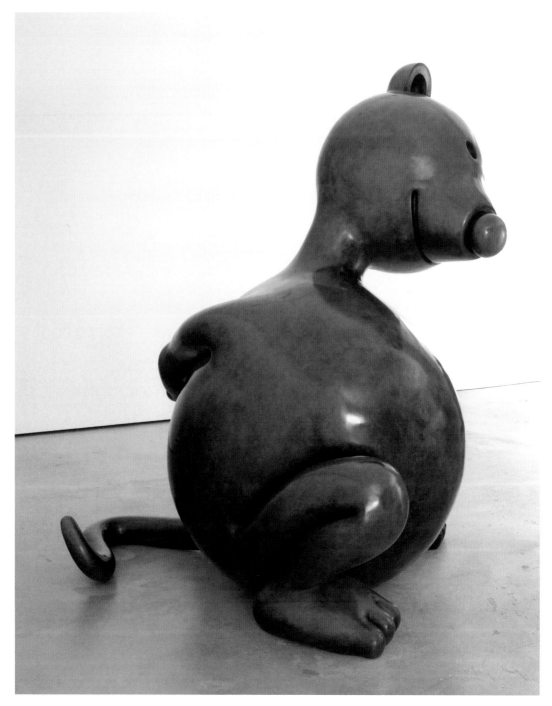

3. **Mouse**, 2007
 bronze, edition of 3, 108 x 54 x 67 in., 274.3 x 137.2 x 170.2 cm

 **Two versions of this sculpture exist, one in an edition of 9, 16½ x 11½ x 12½ in., 41.9 x 29.2 x 31.8 cm
 and another in an edition of 9, 7¼ x 5¾ x 5½ in., 18.4 x 14.6 x 14 cm**

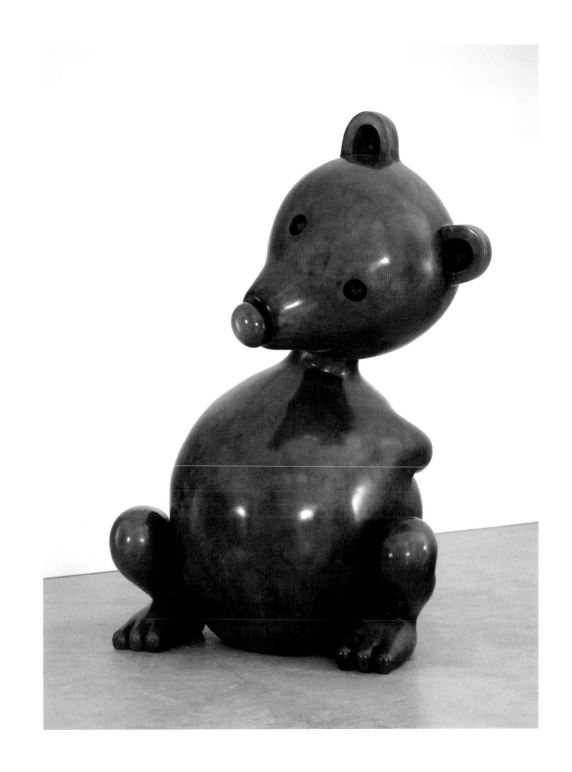

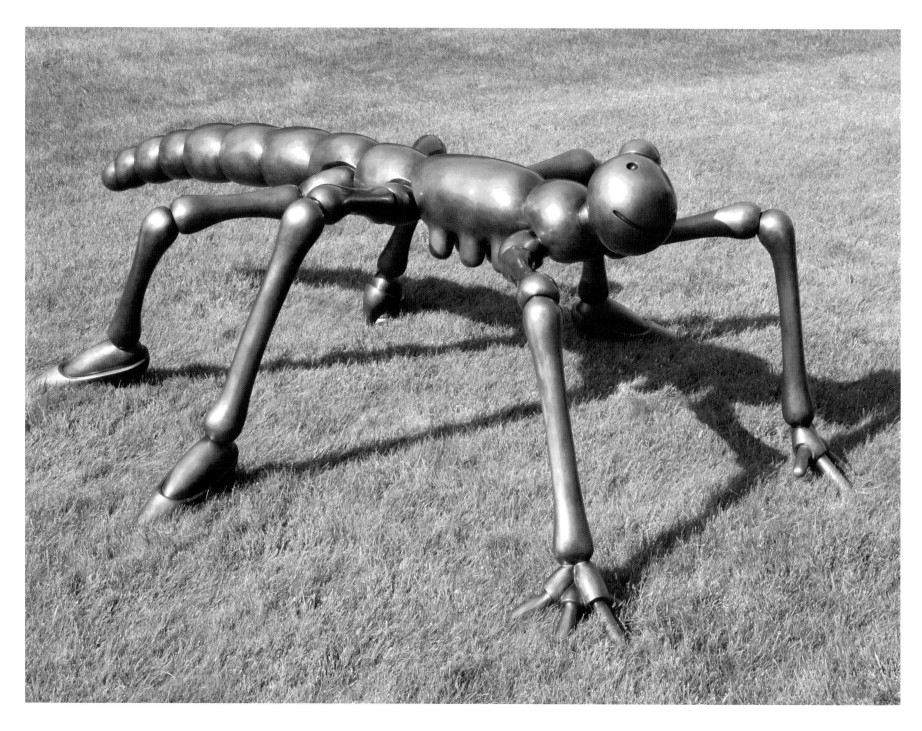

4. **Walking Stick**, 2007
 bronze, edition of 3, 36 x 109 x 83 in., 91.4 x 276.9 x 210.8 cm

 Another version of this sculpture exists in an edition of 9, 9 x 26 x 20 in., 22.9 x 66 x 50.8 cm

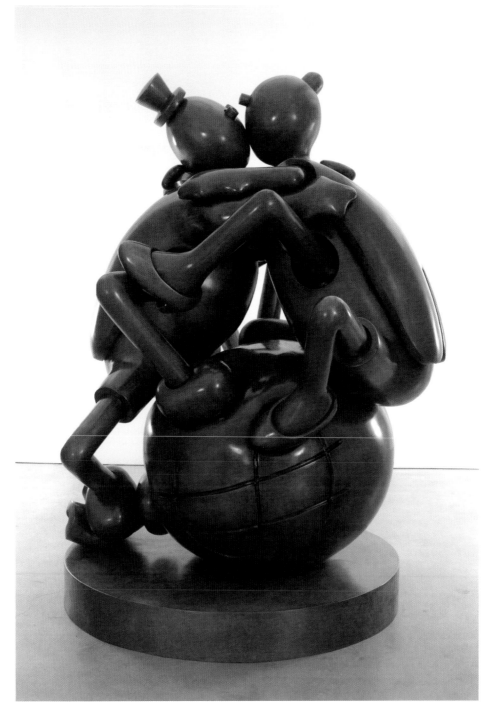

5. **Kissing Dung Beetles**, 2007
bronze, edition of 3, 84 x 59 x 59½ in., 213.4 x 149.9 x 151.1 cm

Another version of this sculpture exists in an edition of 9, 12 x 9 x 8½ inches, 30.5 x 22.9 x 21.6 cm

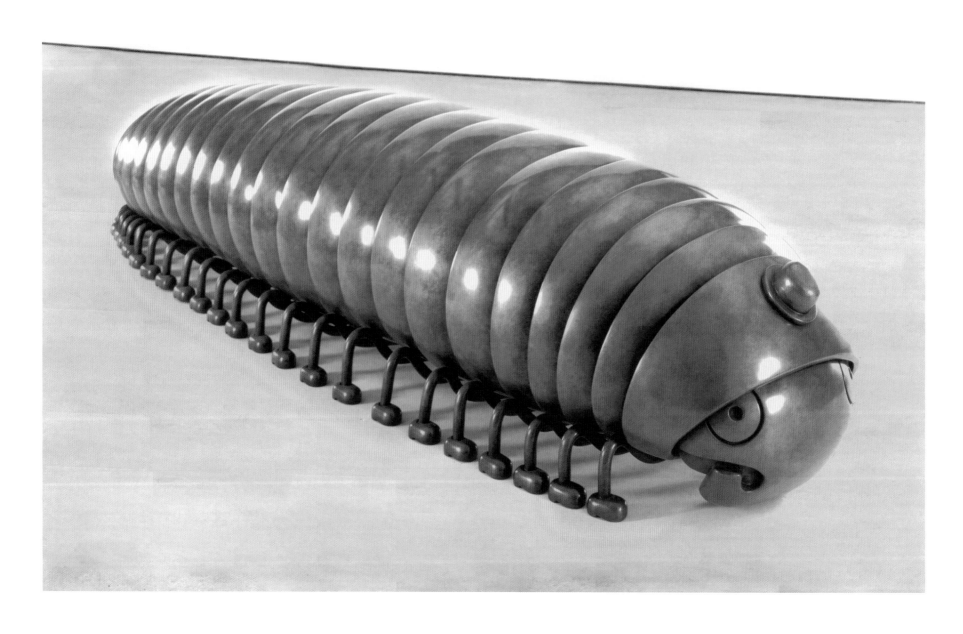

6. **Millipede**, 2006
 bronze, edition of 6, 26 x 125 x 36 in., 66 x 317.5 x 91.4 cm

Another version of this sculpture exists in an edition of 9, 6 x 31½ x 7½ in., 15.2 x 80 x 19.1 cm

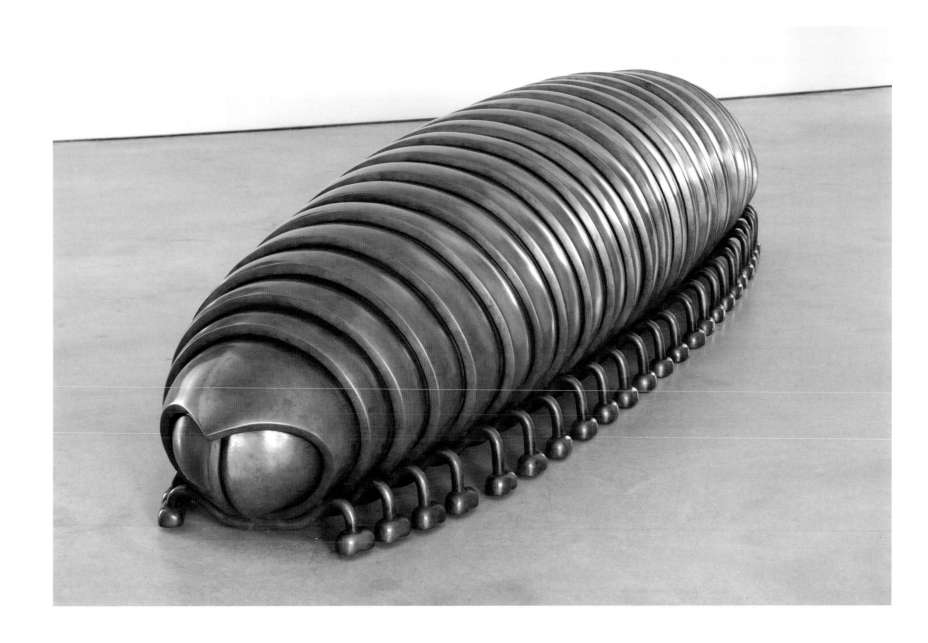

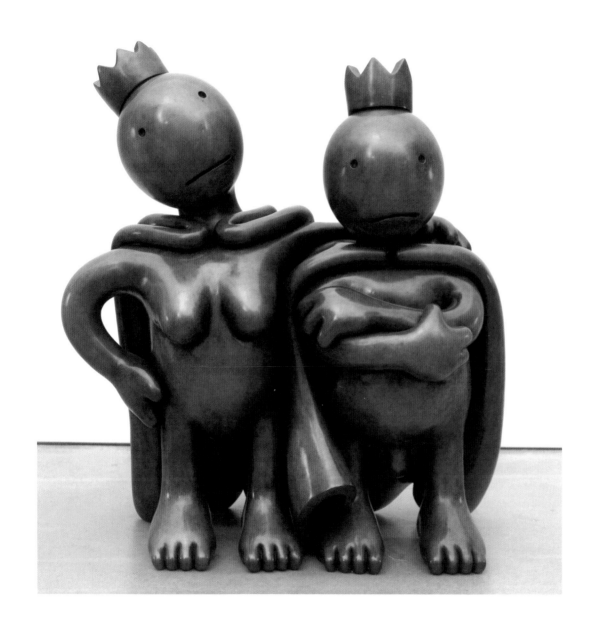

7. **Free Thinkers**, 2007
 bronze, edition of 6, 42 x 41 x 22 in., 106.7 x 104.1 x 55.9 cm

Another version of this sculpture exists in an edition of 9, 6 x 6 x 3¼ in., 15.2 x 15.2 x 8.3 cm

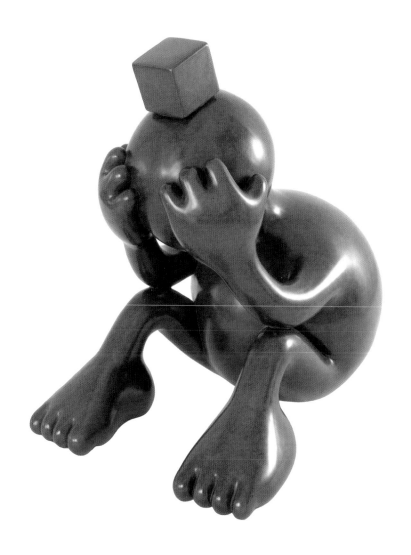

8. **Sad Sphere,** 2007
bronze, edition of 9, 18 x 13 x 20 in., 45.7 x 33 x 50.8 cm

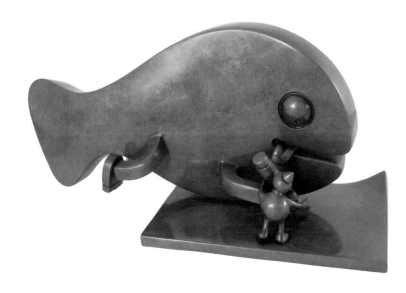

9. **Fish with Pencil,** 2007
 bronze, edition of 9, 17 x 32 x 18 in., 43.2 x 81.3 x 45.7 cm

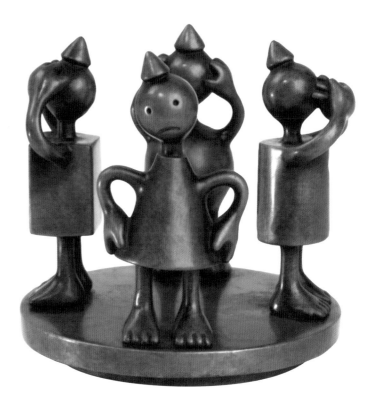

10. **Three Evils and Cone Figure**, 2006
 bronze, edition of 9, 3⅝ x 3¾ x 3¾ in., 9.2 x 9.5 x 9.5 cm

11. **Conceptual Apple**, 2007
bronze, edition of 9, 6½ x 4 x 4 in., 16.5 x 10.2 x 10.2 cm

12. **Building Blocks**, 2007
bronze, edition of 9, 11 x 4 x 5½ in., 27.9 x 10.2 x 14 cm

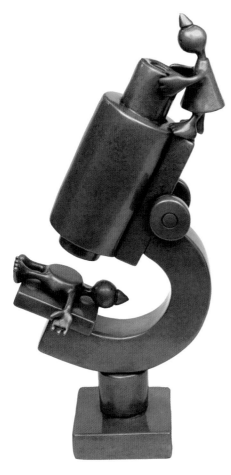

13. **Microscope**, 2007
bronze, edition of 9, 17½ x 9 x 3½ in., 44.5 x 22.9 x 8.9 cm

14. **Woman with Diamond Ring**, 2007
bronze, edition of 9, 13 x 6 x 9 in., 33 x 15.2 x 22.9 cm

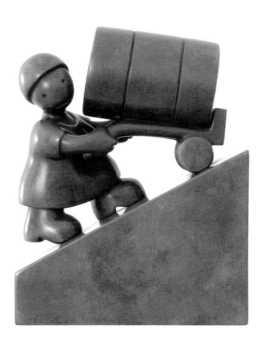

16. **Woman with Oil Barrel**, 2007
bronze, edition of 9, 13 x 6 x 9 in., 33 x 15.2 x 22.9 cm

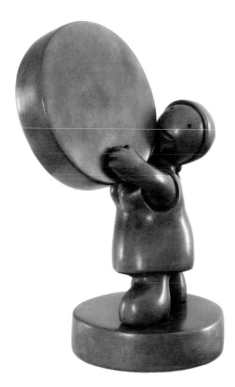

15. **Woman with Two Coins**, 2007
bronze, edition of 9,10¼ x 5¼ x 8 in., 26 x 13.3 x 20.3 cm

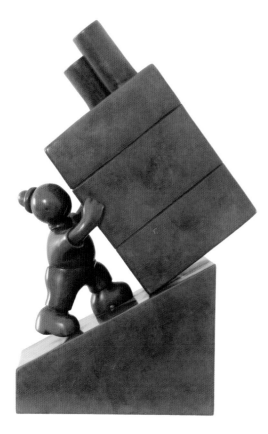

17. **Man with Cigarette Pack**, 2007
bronze, edition of 9, 18 x 6 x 9 in., 45.7 x 15.2 x 22.9 cm

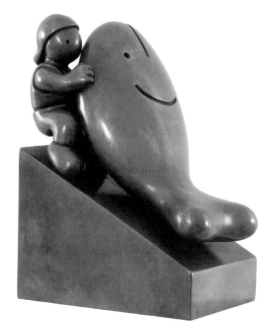

18. **Man with Fish**, 2007
bronze, edition of 9, 13 x 8 x 9 in., 33 x 20.3 x 22.9 cm

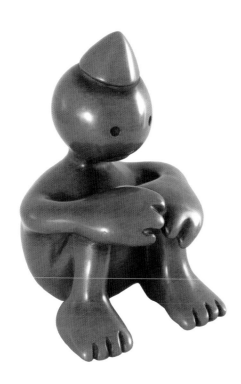

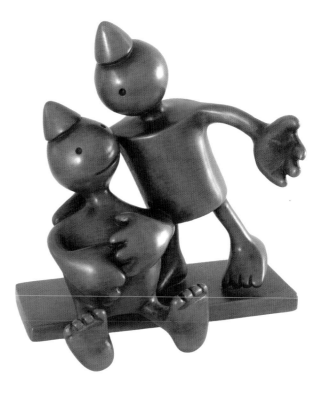

19. **Sitting Sphere**, 2007
 bronze, edition of 9, 3½ x 2½ x 2¾ in., 8.9 x 6.4 x 7 cm

20. **Abstract Couple**, 2007
 bronze, edition of 9, 6 x 5 x 3½ in., 15.2 x 12.7 x 8.9 cm

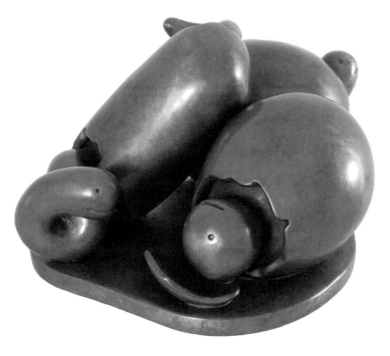

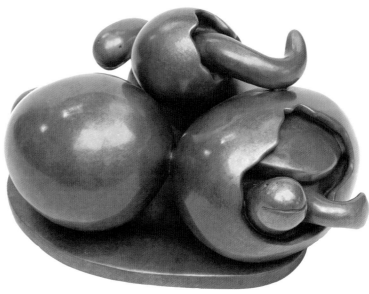

21. **Eggs**, 2007
 bronze, edition of 9, 6 x 13 x 10 in., 15.2 x 33 x 25.4 cm

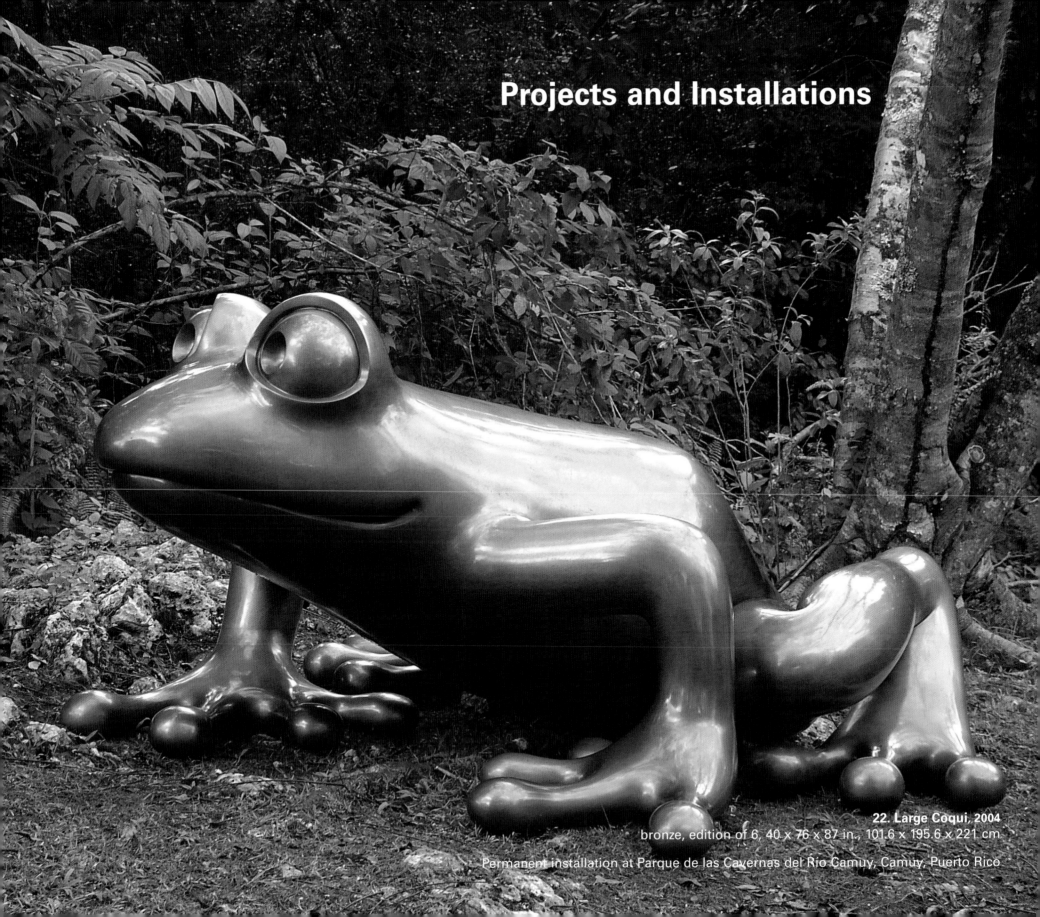

22. Large Coqui, 2004
bronze, edition of 6, 40 x 76 x 87 in., 101.6 x 195.6 x 221 cm
Permanent installation at Parque de las Cavernas del Rio Camuy, Camuy, Puerto Rico

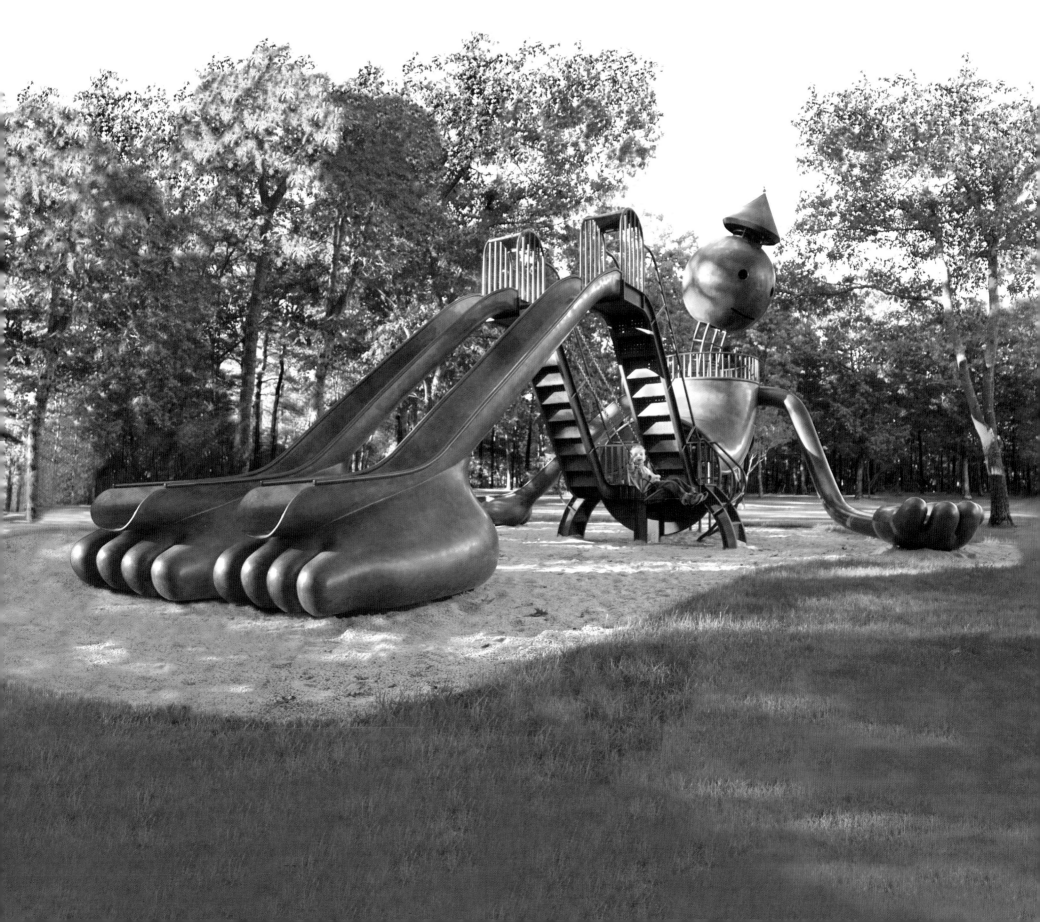

Otterness's *Playground* is an anthropomorphic bronze play struc-
ture that features long slides in each of the figure's two legs, a
swing beneath his bent knees and numerous climbing appara-
tus, including a ladder which leads through the figure's hollow
head into a viewing tower just below his conical hat. This figure
recalls the one depicted in the monumental bronze sculptures
Gulliver, 2002, and *Crying Giant*, 2002, yet reimagines the figure
as an open-armed giant ready for play. To add to the merriment,
Otterness peopled the giant with twenty small figures that can
be found throughout the sculpture – resting in his palm, climb-
ing along the bars, or balancing on top of his hat.

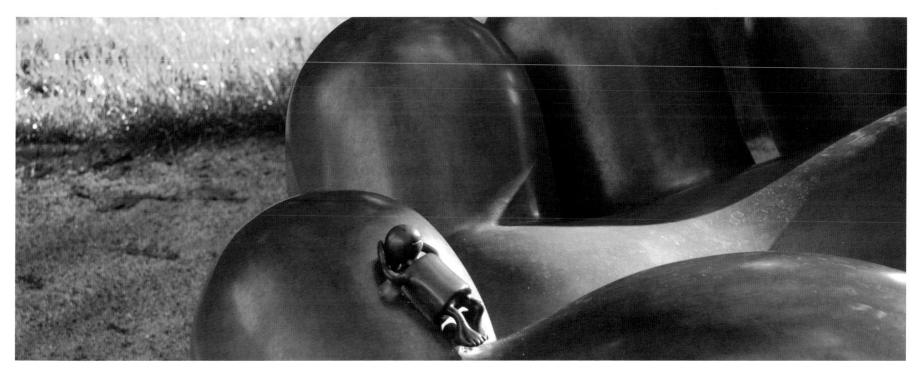

23. Playground, 2007, Private Collection, Cape Cod, Massachusetts
bronze, edition of 6, 360 x 365 x 294 in., 914.4 x 927.1 x 746.8 cm

Playground (details)

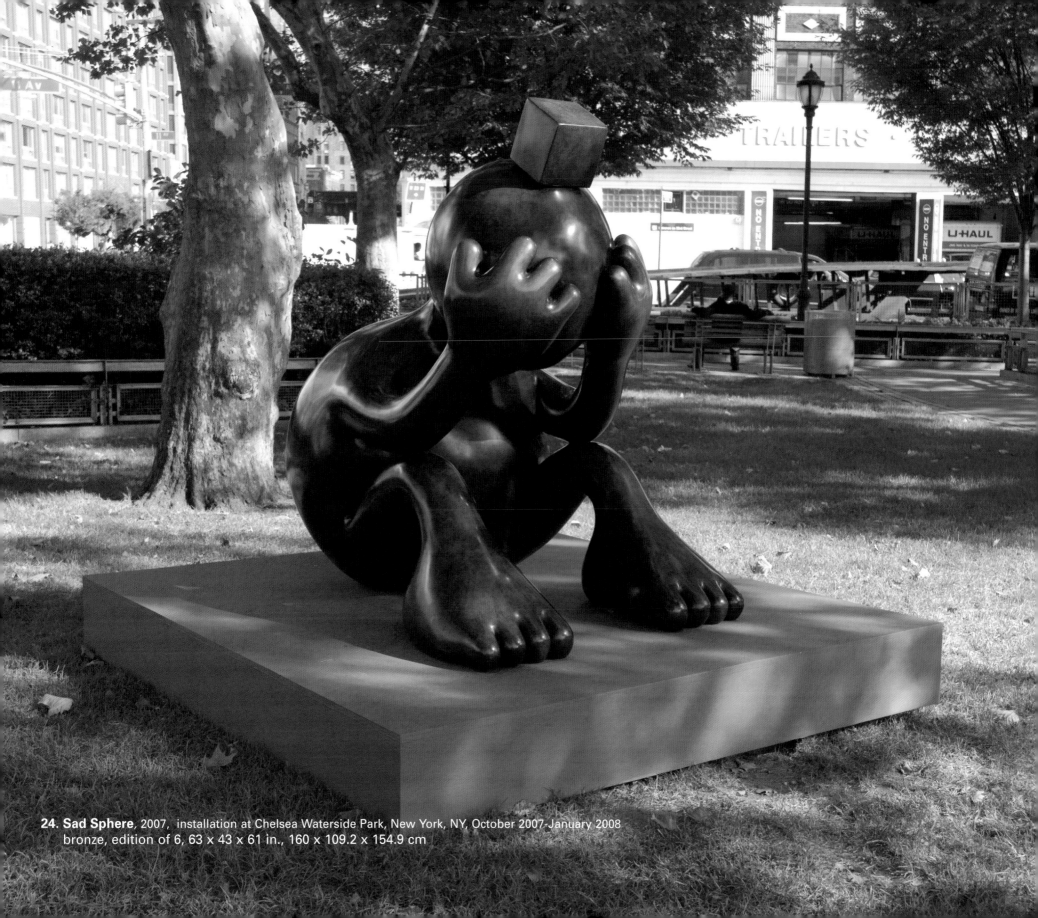

24. Sad Sphere, 2007, installation at Chelsea Waterside Park, New York, NY, October 2007-January 2008
bronze, edition of 6, 63 x 43 x 61 in., 160 x 109.2 x 154.9 cm

List of Work

1. **Immigrant Family**, 2007
 bronze, edition of 3
 129 x 121 x 108 in., 327.7 x 307.3 x 274.3 cm
 illustrated on page 10
 Another version:
 bronze, edition of 9, 2007
 32¾ x 32½ x 32½ inches, 83.2 x 82.6 x 82.6 cm

2. **The Consumer**, 2007
 bronze, edition of 3
 81 x 60 x 92 in., 205.7 x 152.4 x 233.7 cm
 illustrated on page 12
 Another version:
 bronze, edition of 9, 2007
 27 x 30 x 20 in., 68.6 x 76.2 x 50.8 cm

3. **Mouse**, 2007
 bronze, edition of 3
 108 x 54 x 67 in., 274.3 x 137.2 x 170.2 cm
 illustrated on page 14
 Another versions:
 bronze, edition of 9, 2007
 16½ x 11½ x 12½ in., 41.9 x 29.2 x 31.8 cm
 bronze, edition of 9, 2004
 7¼ x 5¾ x 5½ in., 18.4 x 14.6 x 14 cm

4. **Walking Stick**, 2007
 bronze, edition of 3
 36 x 109 x 83 in., 91.4 x 276.9 x 210.8 cm
 illustrated on page 16
 Another version:
 bronze, edition of 9, 2007
 9 x 26 x 20 in., 22.9 x 66 x 50.8 cm

5. **Kissing Dung Beetles**, 2007
 bronze, edition of 3
 84 x 59 x 59½ in., 213.4 x 149.9 x 151.1 cm
 illustrated on page 17
 Another version:
 bronze, edition of 9, 2007
 12 x 9 x 8½ in., 30.5 x 22.9 x 21.6 cm

6. **Millipede**, 2006
 bronze, edition of 6
 26 x 125 x 36 in., 66 x 317.5 x 91.4 cm
 illustrated on page 18
 Another version:
 bronze, edition of 9, 2004
 6 x 31½ x 7½ in., 15.2 x 80 x 19.1 cm

7. **Free Thinkers**, 2007
 bronze, edition of 6
 42 x 41 x 22 in., 106.7 x 104.1 x 55.9 cm
 illustrated on page 20
 Another version:
 bronze, edition of 9, 2007
 6 x 6 x 3¼ in., 15.2 x 15.2 x 8.3 cm

8. **Sad Sphere**, 2007
 bronze, edition of 9
 18 x 13 x 20 in., 45.7 x 33 x 50.8 cm
 illustrated on page 21

9. **Fish with Pencil**, 2007
 bronze, edition of 9
 17 x 32 x 18 in., 43.2 x 81.3 x 45.7 cm
 illustrated on page 22

10. **Three Evils and Cone Figure**, 2006
 bronze, edition of 9
 3⅝ x 3¾ x 3¾ in., 9.2 x 9.5 x 9.5 cm
 illustrated on page 22

11. **Conceptual Apple**, 2007
 bronze, edition of 9
 6½ x 4 x 4 in., 16.5 x 10.2 x 10.2 cm
 illustrated on page 23

12. **Building Blocks**, 2007
 bronze, edition of 9
 11 x 4 x 5½ in., 27.9 x 10.2 x 14 cm
 illustrated on page 23

13. **Microscope**, 2007
 bronze, edition of 9
 17½ x 9 x 3½ in., 44.5 x 22.9 x 8.9 cm
 illustrated on page 24

14. **Woman with Diamond Ring**, 2007
 bronze, edition of 9
 13 x 6 x 9 in., 33 x 15.2 x 22.9 cm
 illustrated on page 24

15. **Woman with Two Coins**, 2007
 bronze, edition of 9
 10¼ x 5¼ x 8 in., 26 x 13.3 x 20.3 cm
 illustrated on page 25

16. **Woman with Oil Barrel**, 2007
 bronze, edition of 9
 13 x 6 x 9 in., 33 x 15.2 x 22.9 cm
 illustrated on page 25

17. **Man with Cigarette Pack**, 2007
 bronze, edition of 9
 18 x 6 x 9 in., 45.7 x 15.2 x 22.9 cm
 illustrated on page 26

18. **Man with Fish**, 2007
 bronze, edition of 9
 13 x 8 x 9 in., 33 x 20.3 x 22.9 cm
 illustrated on page 26

19. **Sitting Sphere**, 2007
 bronze, edition of 9
 3½ x 2½ x 2¾ in., 8.9 x 6.4 x 7 cm
 illustrated on page 27

20. **Abstract Couple**, 2007
 bronze, edition of 9
 6 x 5 x 3½ in., 15.2 x 12.7 x 8.9 cm
 illustrated on page 27

21. **Eggs**, 2007
 bronze, edition of 9
 6 x 13 x 10 in., 15.2 x 33 x 25.4 cm
 illustrated on page 28

Projects and Installations

22. **Large Coqui**, 2004
 bronze, edition of 6
 40 x 77 x 87 in., 101.6 x 195.6 x 221 cm
 illustrated on page 29

23. **Playground**, 2007
 bronze, edition of 6
 360 x 365 x 294 in., 914.4 x 927.1 x 746.8 cm
 illustrated on page 30

24. **Sad Sphere**, 2007
 bronze, edition of 3
 63 x 43 x 61 in., 160 x 109.2 x 154.9 cm
 illustrated on page 32

BIOGRAPHY

1952 Born in Wichita, KS

1970 Arts Students League, New York, NY

1973 Independent Study Program, Whitney Museum of American Art, New York, NY

1977 Member of Collaborative Projects, Inc., New York, NY

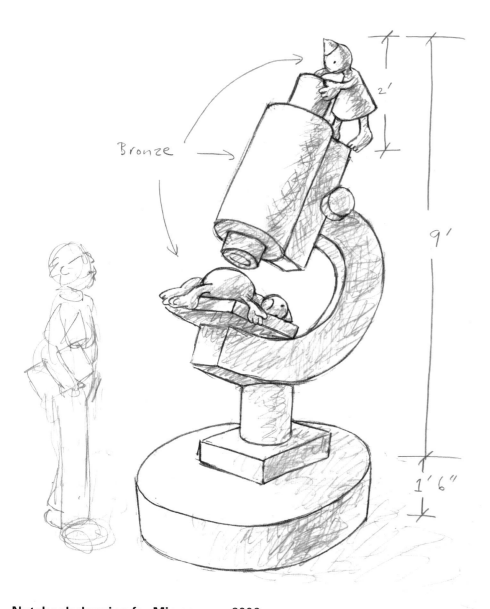

Notebook drawing for Microscope, 2006
pencil on paper

SELECTED SOLO EXHIBITIONS (Post 1990)

1991 *The Tables: Sculptures and Drawings*, IVAM Centre Julio González, Valencia, Spain; traveled to Portikus/ Senckenbergmuseum, Frankfurt am Main, Germany; Haags Gemeentemuseum, The Hague

Nancy Drysdale Gallery, Washington, DC

1992 Brooke Alexander, New York, NY

1993 Galerie Weber, Münster, Germany

John Berggruen Gallery, San Francisco, CA

Tom Otterness: The Tables, The Carnegie Museum of Art, Pittsburgh, PA

1994 *Recent Drawings and Small Objects*, Gallery of Contemporary Art, Krannert Art Museum, Champaign, IL

1995 *Recent Sculpture*, Doris Freedman Plaza, New York, NY; a project of the Public Art Fund

On the Commons, Recent Sculpture, at Metro Tech Center, Brooklyn, NY; a project of the Public Art Fund

Tom Otterness: The Tables, Wichita Art Museum, Wichita, KS

Brooke Alexander, New York, NY

1996 *Tom Otterness: Marriage of Real Estate and Money,* Motel Fine Arts, New York, NY

1997 Marlborough Gallery, New York, NY

Life Underground, Battery Park City Authority, New York, NY

1998 *Tom Otterness: Marriage of Real Estate and Money and Other Recent Projects,* Palm Beach Community College Museum of Art, Lake Worth, FL

1999 *Tom Otterness,* Galería Marlborough, Madrid, Spain

Tom Otterness – Gold Rush – New Sculpture and Drawings, John Berggruen Gallery, San Francisco, CA

2002 *Free Money and Other Fairy Tales,* Marlborough Gallery, New York, NY and Marlborough Chelsea, New York, NY

2003 *Bombeater,* Skoto Gallery, New York, NY

2004 *Several Strange Objects,* John Berggruen Gallery, San Fransisco, CA

Tom Otterness on Broadway, New York, NY

2005 *Tom Otterness in Indianapolis,* Indianapolis, IN

2006 *Tom Otterness in Grand Rapids: The Gardens to The Grand,* Grand Rapids, MI

Tom Otterness in Beverly Hills, Beverly Hills City Hall, Beverly Hills, CA

SELECTED GROUP EXHIBITIONS (Post 1990)

1991 *No Laughing Matter;* traveling exhibition organized by Independent Curators International, New York, NY, through 1993

Rope, Galeria Fernando Alcolea, Barcelona, Spain

Couleurs de l'argent (The Color of Money), Musée de la Poste, Paris, France

About Round Round About, Anders Tornberg Gallery, Lund, Sweden

1992 *Allegories of Modernism*, The Museum of Modern Art, New York, NY

Body, Leg, Heads and Special Parts, Westfaelischer Kunstverein, Munich, Germany

1993 *Art, Money & Myth*, Palm Beach Community College Museum of Art, J. Patrick Lannan Gallery, Lake Worth, FL

The Elusive Object: Selections from the Permanent Collection, Whitney Museum of American Art, Stamford, CT

1994 *Eleventh Biennial Benefit*, San Francisco Museum of Modern Art, San Francisco, CA

Jahresmuseum 1994, Kunsthaus Murzzuschlag, Switzerland

1996 *Twentieth Century American Sculpture at the White House, Exhibition IV*, Washington, DC

A Century of American Drawing from the Collection, The Museum of Modern Art, New York, NY

1997 *American Art in the Age of Technology*, San Jose Museum of Art, San Jose, CA

Contemporary Sculpture: The Figurative Tradition, Woodson Art Museum, Wasau, WI

1998 *An Exhibition for Children*, 242, New York, NY

1999 *Important Sculptors of the Late Twentieth Century*, Stamford Sculpture Walk, Stamford, CT

2000 *Drawings and Photographs,* Mathew Marks Gallery, organized by the Foundation for Contemporary Performance Art, New York, NY

Imaginary Beings, Exit Art, New York, NY

DNCArt, a project for the Democratic National Committee, New York, NY

American Sculpture, International Sculpture Festival of Monte-Carlo, Monte-Carlo, Monaco

2001 *Retorn al País de les Meravelles L'Art Contemporani i la Infancia*, Centre Cultural de la Fundació, Barcelona, Spain

Lighten Up: Art with a Sense of Humor, De Cordova Museum Sculpture Park, Lincoln, MA

2003 *Amazing Animal Exposition*, Grounds for Sculpture, Hamilton, NJ

American Dream: A Survey, Ronald Feldman Gallery, New York, NY

Polarities, The Lobby Gallery, New York, NY

Invitational Exhibition of Painting and Sculpture, American Academy of Arts and Letters, New York, NY

2004 *Subway Style: Architecture and Design in the New York City Subway*, UBS Gallery, New York, NY

Open House: Working in Brooklyn, Brooklyn Museum, Brooklyn, NY

New York, New York, Galería Marlborough, Madrid, Spain

Public Art in the Bronx, Lehman College Art Gallery, The City University of New York, Bronx, NY

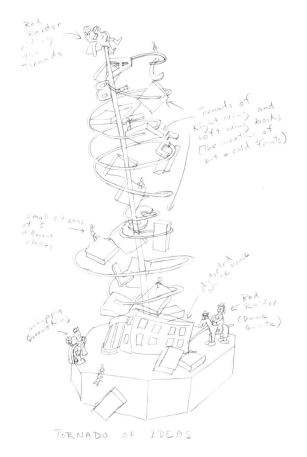

Notebook drawing for Tornado of Ideas, 2003
pencil on paper

Empire: Videos from a New World Order, Maryland Institute College of Art, Baltimore, MD

2005 *Sculptures Monumentales à Saint Tropez*, La Citadelle, Saint Tropez, France

Salamanca ciudad de la escultura, Salamanca, Spain

2007 *Wit & Whimsy*, Marlborough Gallery, New York, NY

Art in the Green, Winter Park, FL

Sobre el Humor, Galería Marlborough, Madrid, Spain

PUBLIC COMMISSIONS (Post 1984)

1984 *Kings Parade*, Büchhandlung Walther König, Cologne, Germany

1991 *The New World*, The Edward R. Roybal Federal Building, General Services Administration, Los Angeles, CA

1992 *The Real World*, The Governor Nelson A. Rockefeller Park Battery Park City Authority, New York, NY

1993 *Upside-Down Feet*, Krannert Museum of Art, University of Illinois, Urbana-Champaign, Champaign, IL

Die Überfrau, State Library, Münster, Germany

1995 *Dreamers Awake*, Wichita Art Museum, Wichita, KS

Untitled, Eli Broad Family Foundation, Santa Monica, CA

1996 *The Marriage of Real Estate and Money*, Roosevelt Island, NY

1997 *Visionary*, Metro Tech Center, Brooklyn, NY

Law of Nature, The Mark O. Hatfield US Courthouse, General Services Administration, Portland, OR

1998 *The Gates*, Cleveland Public Library, in collaboration with Maya Lin (Artist) and Tan Lin (Poet)

1999 *Rockman*, Federal Courthouse, General Services Administration, Minneapolis, MN

Feats of Strength, Western Washington University, Bellingham, WA

The Music Lesson, Music School, University of North Carolina at Greensboro, NC

Gold Rush, Federal Courthouse, General Services Administration, Sacramento, CA

2000 *Time and Money*, Hilton Hotel at Times Square, Forest City Ratner Corporation, New York, NY

2001 *Suspended Mind*, Carl Sagan Discovery Center, Montefiore Children's Hospital, Bronx, NY

2002 *Life Underground,* Metropolitan Transit Authority and Arts for Transit, 14th Street and 8th Ave., New York, NY

Untitled, Branchbrook Park Station, New Jersey Transit, Newark, NJ

2003 *The Return of the Four-Leggeds*, Northwest Museum of Arts and Culture, Washington State Arts Commission, Spokane, WA

2004 *El Coqui Gigante de Las Cavernas del Rio Camuy*, Las Cavernas del Rio de Camuy, Puerto Rico

Untitled, Beelden aan Zee Museum, Scheveningen, Netherlands

Tornado of Ideas, Texas Tech University, Lubbock, TX

2005 *Large Frog and Bee*, Montefiore Childrens Hospital, Bronx, NY

Amorphophallus titanum, The New York Botanical Garden, Bronx, NY

2007 *Immigrant Family*, Toronto, Canada

SELECTED PUBLIC COLLECTIONS

Arts Council of Indianapolis, Indianapolis, IN

Beelden aan Zee Museum, The Hague, Netherlands

The Brooklyn Museum of Art, New York, NY

Eli Broad Family Foundation, Santa Monica, CA

Carnegie Museum of Art, Pittsburgh, PA

Dallas Museum of Art, Dallas, TX

Delaware Art Museum, Wilmington, DE

Gateway Foundation, St. Louis, MO

Grounds for Sculpture, Hamilton, NJ

Solomon R. Guggenheim Museum, New York, NY

Hunter Museum of American Art, Chattanooga, TN

Israel Museum, Jerusalem, Israel

IVAM Centre Julio González, Valencia, Spain

Kemper Museum of Contemporary Art, Kansas City, MO

Frederik Meijer Gardens and Sculpture Park, Grand Rapids, MI

The Miyagi Museum of Art, Sendai, Japan

The Museum of Modern Art, New York, NY

Nassau County Museum of Art, Roslyn Harbor, NY

Palm Beach Community College Museum of Art, Lake Worth, FL

San Francisco Museum of Modern Art, San Francisco, CA

Museo Rufino Tamayo, Mexico City D.F., Mexico

Weatherspoon Art Gallery, Greensboro, NC

Whitney Museum of American Art, New York, NY